THE BODY IN PIECES

THIS IS THE TWENTY/SIXTH OF THE
WALTER NEURATH MEMORIAL LECTURES
WHICH ARE GIVEN ANNUALLY EACH SPRING ON
SUBJECTS REFLECTING THE INTERESTS OF
THE FOUNDER
OF THAMES & HUDSON

THE DIRECTORS

OF THAMES & HUDSON

WISH TO EXPRESS THEIR GRATITUDE

TO THE TRUSTEES OF

THE NATIONAL GALLERY, LONDON,

FOR GRACIOUSLY HOSTING

THESE LECTURES

THE BODY IN PIECES

THE FRAGMENT AS A METAPHOR OF MODERNITY

LINDA NOCHLIN

THAMES & HUDSON

Any copy of this book issued by the publisher as a paperback is sold subject to the condition that it shall not by way of trade or otherwise be lent, resold, hired out or otherwise circulated without the publisher's prior consent in any form of binding or cover other than that in which it is published and without a similar condition including these words being imposed on a subsequent purchaser.

The Walter Neurath Memorial Lectures, up to 1992, were given at Birkbeck College, University of London, whose Governors and Master most generously sponsored them for twenty-four years.

© 1994 Linda Nochlin

First published in hardcover in the United States of America in 1995 by Thames & Hudson Inc., 500 Fifth Avenue, New York, New York 10110

thamesandhudsonusa.com

First paperback edition 2001

Library of Congress Catalog Card Number 94/61110 ISBN 0-500-28305-2

All Rights Reserved. No part of this publication may be reproduced or transmitted in any form or by any means, electronic or mechanical, including photocopy, recording or any other information storage and retrieval system, without prior permission in writing from the publisher.

Printed and bound in Italy by Editoriale Bortolazzi-Stei srl

I would like to express my thanks to Mrs Eva Neurath and the Neurath family for inviting me to give the 1994 Walter Neurath Memorial Lecture. I never knew Walter Neurath, but the distinction and the rich variety of the books published by Thames & Hudson surely attest to the high standard he established in founding the firm. As a graduate student at the Institute of Fine Arts at New York University many years ago, I studied with great scholars – idiosyncratic, large-spirited, brilliant - who came from that tradition of German and Austrian humanistic scholarship that was Walter Neurath's tradition as well. Despite the fact that I have sometimes quite combatively moved in different directions — sex and gender were not the primary objects of my graduate education – I must nevertheless pay tribute to my teachers and their tradition, not only for increasing my store of learning but also for encouraging me to go my own way. This meant to engage in social history and to investigate the relationship between art and politics back in the early 1950s, a time when such directions were decidedly unpopular, even dangerous, in McCarthyite America. I started my academic career as a philosopher, my nonacademic one as a painter and poet. My graduate school teachers, mostly refugees from Hitler, transplanted into a new and different world, were sympathetic and supportive of these maverick strains in my work. This lecture will, I hope, in some way pay tribute to the best qualities of that education, no matter how different my own way of looking at the history of art may be.

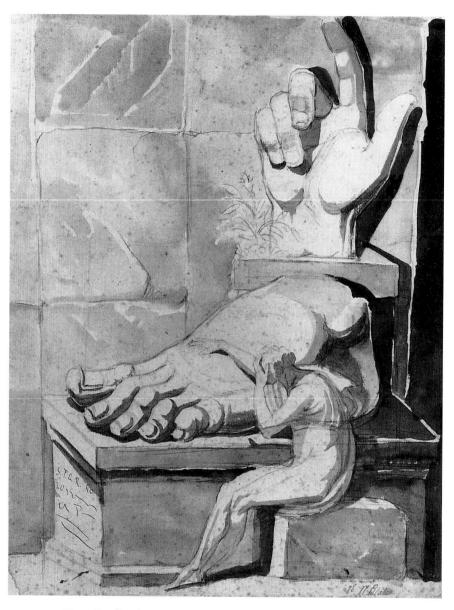

1 Henry Fuseli, The Artist Overwhelmed by the Grandeur of Antique Ruins, 1778-79.

NO IMAGE SERVES better to introduce my subject than Henry Fuseli's Artist Overwhelmed by the Grandeur of Antique Ruins. Modernity, in this memorable red chalk and sepia wash drawing, is figured as irrevocable loss, poignant regret for lost totality, a vanished wholeness. So devastated is the artist by this loss that he cannot even see; he is represented as self-blinded. With one hand covering his eyes, he gently and lovingly extends his other arm to embrace, and at the same time to palp, the extent, volume and texture of the giant foot at his side. Touch is the sense in question here, suggested both by the gesture and by the formal qualities of the drawing itself.

The heroic energy of the past is evoked by the eloquent modelling of the individual toes, the joints articulated with muscular crispness in emphatic brown wash; the instep of the fragmented foot bulges forth like a body-builder's pectoral, so deeply incised is it by modelling shadow. Even the toenails, not an anatomical feature generally thought of as capable of bearing the weight of symbolic reference, crackle with emphatic linear energy and the foot as a whole dominates its base with a stance of assured self-possession. The upward pointing hand, frozen in the imperial gesture of authority and just escaping cropping by the upper margin of the picture frame, can be read in much the same way; it is as though the boundaries of the image can barely contain such monumental and expansive grandeur even in its ruin. Both background and foreground are constituted as a kind of grid, two-dimensional or extended into the narrow space of the pictorial stage, precisely for the purpose of measuring off the vast scale of the antique fragments in relation to the pathetic smallness of the foreground figure.

This figure, of the artist, is presented as a total entity. 'Modern' insofar as he can be identified with Fuseli himself, though generic in type, he is,

by comparison with the fragmented grandeur of the past, lacking.¹ His little feet, almost feminine in their daintiness, seem hardly capable of bearing his weight; his hands, far from wielding authority, shield and grope. His body, if not specifically weak, has a larva-like tubularity, and a torso disempowered by grief and delicacy of tonal contrast.

The artist is not merely 'overwhelmed' but is in mourning, mourning a terrible loss, a lost state of felicity and totality which must now inevitably be displaced into the past or the future: nostalgia or Utopia are the alternatives offered by Fuseli's image, ten years before the outbreak of the French Revolution.

And yet the loss of the whole is more than tragedy. Out of this loss is constructed the Modern itself. In a certain sense, Fuseli has constructed a distinctively *modern* view of antiquity-as-loss — a view, a 'crop', that will constitute the essence of representational modernism.

It is the French Revolution, the transformative event that ushered in the modern period, which constituted the fragment as a positive rather than a negative trope. The fragment, for the Revolution and its artists, rather than symbolizing nostalgia for the past, enacts the deliberate destruction of that past, or, at least, a pulverization of what were perceived to be its repressive traditions. Both outright vandalism and what one might think of as a recycling of the vandalized fragments of the past for allegorical purposes functioned as Revolutionary strategies.

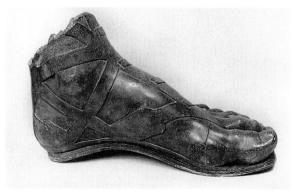

2 Fragment of a foot of an equestrian statue of Louis XIV, c. 1699.

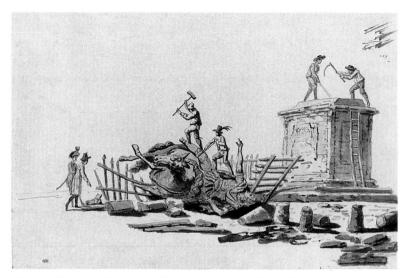

3 Jacques Bertaux, Destruction of the Equestrian Statue of Louis XIV, 1792.

One of the most memorable installations at the 'Révolution Française et l'Europe' exhibition at the Grand Palais in Paris in 1989 was a giant sculptural collage made out of mutilated statues of the French kings mammoth toes, a giant hand, a horse's hoof – fragments of equestrian statues of Louis XIV, Louis XV and Henri IV – as well as a fallen bust of Louis XVI himself.2 On the other side of the floor-to-ceiling screen, there was nothing but a small engraving by Jacques Bertaux of the destruction of François Girardon's equestrian statue of Louis XIV in 1792, and a single, beautifully modelled foot from this colossal sculpture, as eloquent in its isolation, its suggestion of the passage of earthly grandeur, as Fuseli's famous drawing of the Artist Overwhelmed by the Grandeur of Antique Ruins. Fragmentation, mutilation and destruction might be said to be the founding tropes of the visual rhetoric here. At the same time, the Grand Palais installation evoked actual, historical acts of Revolutionary iconoclasm. One such was the taking apart of the statue of Louis XV to make way for a representation of Liberty surmounting a pedestal festooned with fragmentary symbols of royal power - crowns, orbs, sceptres – for J.-L. David's Festival of Unity and Indivisibility.3 Another was David's projected statue of Hercules, a colossus dedicated to the glory of the French people, which was to overcome symbolically the 'double tyranny of kings and priests' by standing on a base constructed from the debris of the statues of kings wrested from the porticoes of Notre Dame.⁴

Put in its simplest terms, the omnipresence of the fragment – in a variety of forms and with a wide range of possible significance – in the visual representation of the French Revolution had something to do with the fact that 'the French Revolution was caught in the throes of destroying one civilization before creating a new one'.5 Yet the actual task facing those who sought to carry out the Revolutionary mandate was far from simple. If David maintained that the Revolution must begin by 'effacing from our chronology so many centuries of error', it nevertheless remained to be decided exactly what the 'errors' were, and how they were to be effaced. The notion of 'vandalism' - wanton destruction of culturally valuable objects by the uninstructed popular will - arose almost simultaneously with the notion of conservation: officially sanctioned saving of the nation's cultural patrimony. Little by little, in the name of a higher good, the people were deprived of the right to destroy the icons of feudalism.6 Nevertheless, the imagery – and the enactment - of destruction, dismemberment and fragmentation remained powerful elements of Revolutionary ideology at least until the fall of Robespierre in 1794 and even after.

At the heart of this iconography of destruction, however, lies that archetype of human dismemberment constituted by the guillotining of the victims of the Terror. The guillotine itself was figured as uniquely modern in the revolutionary *imagination*, as Daniel Arasse has pointed out in *La Guillotine et l'imaginaire de la Terreur*. In depersonalizing the solemn occasion of public execution; in serializing and standardizing the act; in the supposedly scientific efficacy of its technology; and, above all, in its 'instantaneity', its reduction of the temporal span associated with death to a mere blink of the eye, 8 the guillotine was viewed as a specifically contemporary instrument of state-sanctioned death.

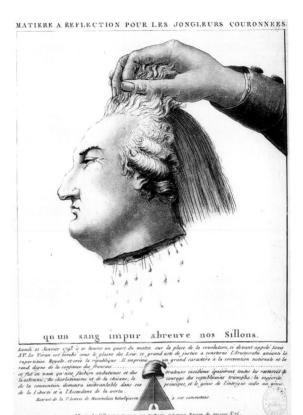

4 Villeneuve, Matière à réflection pour les jongleurs couronnées (Food for Thought for Crowned Charlatans), 1793.

Most significantly, this iconography is centred about that primal scene of political transgression: the beheading of the king. The topos of the execution of the monarch, a castration image of unprecedented power and suggestiveness, is central to the Revolutionary discourse of destruction. The wresting of the head from the fleshly embodiment of the State constituted an irreversible enactment of the destruction of the old regime.

Representations of the execution of the monarch range from the laconic ferocity of an *ostensio* of the severed head, displayed, like that of the Medusa, by a detached hand to an invisible crowd, in a memorable engraving published by Villeneuve, to the complexity of a richly

5 Pierre-Etienne Lesueur, Execution of Louis XIV, 1793.

allegorized drawing of the scene by Pierre-Etienne Lesueur. In the case of the latter (a fully worked out project submitted to the Revolutionary Competition of the Year II), the subject of the ostension of the severed head, in conjunction with the allegorization of various members of the animated crowd — embracing; pledging allegiance to the state not on swords but on the body of a strategically placed cannon; holding aloft a banner surmounted with a Phrygian cap, the banner inscribed with the words 'Death to the Tyrants: Liberty, Equality: Long Live the Republic, One and Indivisible'; or engaging in an extraordinary ritual dance, half-classical, half-carmagnole, at the foot of the scaffold — all conjoin to create a sense of ecstatic transcendence that is far removed from mere reportage. To Human sacrifice is the secret agenda here. To borrow

the words of Daniel Arasse, 'The Revolution founded its own legitimacy and its own sanctity (sacralité) on the sacredness (sacralisation) of the personage (personne) of the king; it turned this to its profit and established the one by abolishing the other . . . The blade of the guillotine functioned as the instrument of an expiatory sacrifice.' Even more naturalistic, ostensibly eye-witness accounts of the guillotining of upper-class victims were often enriched by allegorical addenda. In a pen-and-wash drawing of a multiple execution of aristocrats by a Swedish admirer of the Republic, Carl August Ehrensvärd, a nude, club-wielding Hercules, emblem of the power of the people, occupies the foreground.

6 Carl August Ehrensvärd, Democrats Mingling with the Aristocracy, mid-1790s.

The poles of the figuration of the body in pieces as an exemplary Revolutionary trope are represented by two, rather startling, images. The first, an anonymous canvas, embodies the notion of fragmentation as sacrifice. It is an odd little painting, awkward, silly, horrifying and moving all at once, representing a hero so devoted to the welfare of the nation that he has literally, in a modernized exemplum virtutis, given his right arm for it in battle. The arm itself, painted with a high degree of naturalism, is displayed prominently on an altar-like table in the foreground, tenderly wrapped in white linen; in its macabre isolation, it looks back to the holy relics of saints, and, at the same time, forward to the entirely secular still lifes of fragmented limbs created by Géricault early in the nineteenth century, or even to Van Gogh's Self-portraits with Bandaged Ear later on.

7 Anonymous, Devotion to One's Country, c. 1794.

8 James Gillray, Un Petit Souper à la Parisienne, or, A Family of Sans-Culotts Refreshing after the Fatigues of the Day, 1792.

At the opposite pole of Revolutionary representation lies the topic of fragmentation as obscenity, here figured by Britain's prime satirist of Revolutionary excess, James Gillray. Gillray's sense of the grotesque knows no limits of decorum or propriety. The far-out, radical cartoonists of the 1960s look positively timid and repressed in comparison with prints like Un Petit Souper à la Parisienne (also known as A Family of Sans-Culotts [sic] Refreshing after the Fatigues of the Day), a coloured etching of 1792. Fragments and dismemberment are at issue here, too; and again a table is featured prominently in the foreground, but, in this case, it is the setting for cannibalism and bestiality rather than sacrifice. The Revolution, in Gillray's version of it, hyperbolic in its destruction of all limits, hierarchy and decorum, is representable only by a language of excess: the body in pieces as cannibalism.

9 Théodore Géricault, The Wounded Cuirassier, 1814.

In the post-Revolutionary generation of artists, it is Géricault who most violently exploits the message of castration implicit in the representation of the fragmented, or wounded, male body. Such imagery would be unthinkable without the memory of Revolutionary violence, the nightmare of the guillotine, or, in the case of repeated pictures of wounded men, the loss of French political potency after the fall of Napoleon.

9, 11, 12

10

Géricault's rather matter of fact if poignant depictions of Napoleonic anti-heroes, whose bodies are quite literally 'in pieces' — broken, amputated — serve to remind us that there are times in the history of modern representation when the dismembered human body exists for

10 Théodore Géricault, Execution in Italy, 1816.

11 Théodore Géricault, *The Swiss* Guard at the Louvre, 1819.

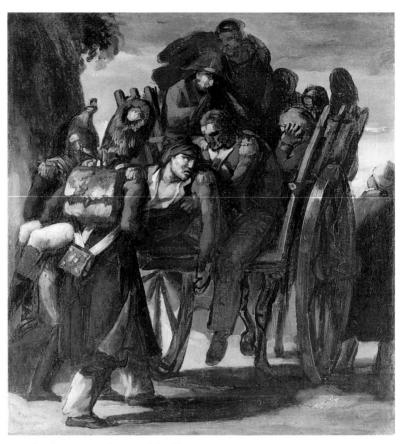

12 Théodore Géricault, Wounded Soldiers in a Cart, c. 1818.

the viewer not just as a metaphor but as an historical reality. Art historians like myself, wrapped up in the nineteenth century and in gender theory, have a tendency to forget that the human body is not just the object of desire, but the site of suffering, pain and death, a lesson that scholars of older art, with its insistent iconography of martyrs and victims, of the damned suffering in hell and the blessed suffering on earth, can never ignore.

13, 14

In Géricault's paintings of anatomical fragments – severed arms and legs, in this case – the coherence of the body is totally shattered. The dispersed fragments are then reconjoined at the will of the artist in arrangements both horrific and elegant, dramatically isolated by shadow, their sensual veracity both as individual elements and as aesthetic construction intensified by what seems like candlelight spotlighting. The mood of these works shockingly combines the objectivity of science – the cool, clinical observation of the dissecting table – with the paroxysm of romantic melodrama.

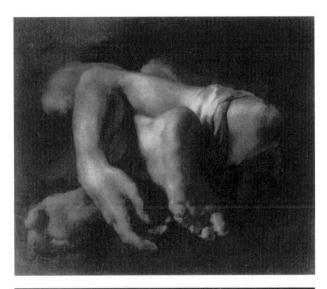

13 Théodore Géricault, Severed Limbs, 1818.

14 Théodore Géricault, Severed Limbs, c. 1819.

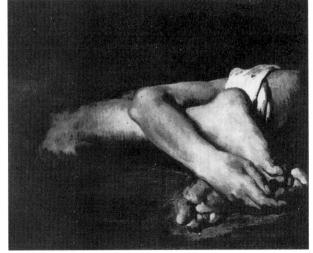

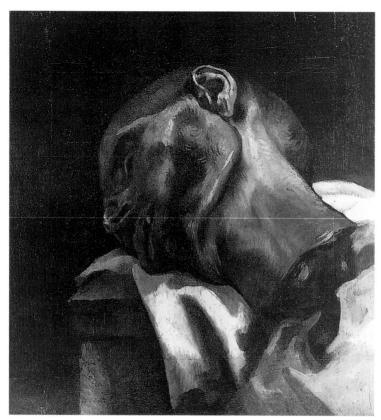

15 Théodore Géricault, Head of a Dead Man, c. 1818–19.

16 Théodore Géricault, Severed Heads, 1818.

As Nina Athanassoglou-Kallmyer has observed, the taste for horror exhibited in Géricault's body fragment paintings and, even more, in his still lifes of severed heads, is a response the artist shared with several of his literary and artistic contemporaries and one which had a far-reaching aesthetic and political agenda. ¹² Yet what interests me in associating the human fragment with an ever-changing concept of modernity is how unique these images are in their formal and expressive construction; how they foreground not merely the romantic horror of the situation, but, even more, the absolute abjectness of these subjects. And this is done by quite specific and utterly original formal means: consigning the human elements to the realm of the horizontal. In both paintings, the one ironically

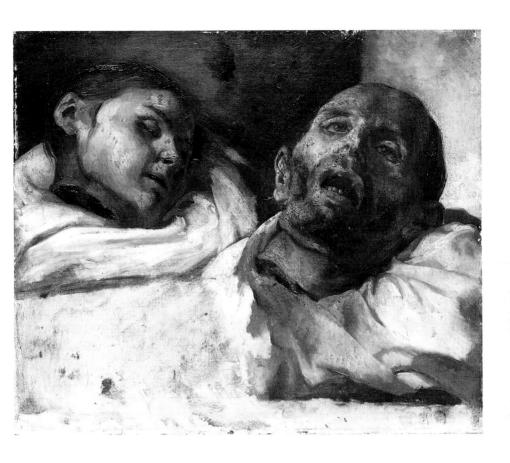

conjoining a male and a female head (a conjunction usually associated with the erotic rather than the mortuary mode and here further ironized by the pretty shawl effect for the woman), the other representing a single male head, the subjects are deployed on a horizontal surface rather than being displayed on the vertical plane. As Rosalind Krauss has suggested in her 1993 study of the contemporary artist Cindy Sherman, borrowing the term from Gestalt psychology, 'the plane of verticality is the plane of *Prégnanz* . . . the hanging together or coherence of form. . . . Further, this vertical dimension, in being the axis of form, is also the axis of beauty.' ¹³ The plane of the horizontal is desublimatory, associated with 'base materialism'. ¹⁴ By laying them out, in perspective, on a horizontal surface,

16

IS

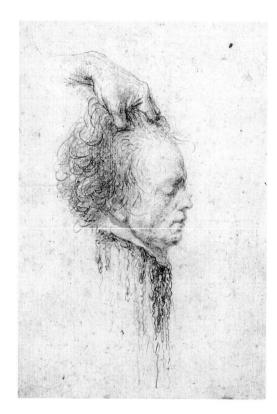

17 Dominique Vivant Denon, Severed Head of Robespierre, 1794.

18 Charles-Emile Callande de Champmartin, *After Death, Head of a Dead Man*, 1818–19.

Géricault consigns the mutilated heads to the realm of the object, plays their erstwhile role as the most significant part of the human body against their present condition as lifeless, gruesome fragments, deployed on a tabletop like meat on a butcher's counter or specimens on a dissecting table. Yet, even more disturbingly, the heads have been arranged for maximum effect by the controlling artist: Géricault's project here is an aesthetic one, involving formal intervention.

The unique innovation of recourse to the horizontal can better be understood if Géricault's severed head pictures are compared with even such a veracious, on the spot drawing as Vivant Denon's pencil recording of the head of Robespierre held up by the executioner's hand, which has a kind of iconic dignity, the aura of subjecthood supplied by its vertical, upright position; or with a painting, until recently attributed

17

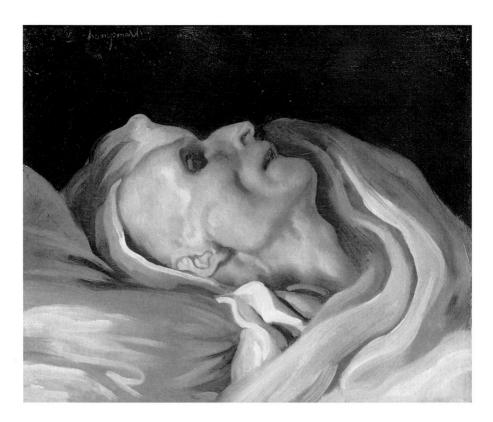

to Géricault but now given to his close friend and disciple, Callande de Champmartin, which is afforded a kind of decorative self-assertiveness because of the perky upright parallelism of head with the vertical backplane — an effect utterly foreign to Géricault's formal inscription of the most chilling debasement of the human fragment.

So far, I have been dealing quite literally with the body in pieces, the fragmented body and its variable significations in the visual representation of the modern period. But what of the larger implications of the topic, what of that sense of social, psychological, even metaphysical fragmentation that so seems to mark modern experience — a loss of wholeness, a shattering of connection, a destruction or disintegration of permanent

18

value that is so universally felt in the nineteenth century as to be often identified with modernity itself?

'All fixed, fast-frozen relations, with their train of ancient and venerable prejudices and opinions, are swept away, all new-formed ones become antiquated before they can ossify. All that is solid melts into air, all that is holy is profaned and men at last are forced to face . . . the real conditions of their lives and their relations with their fellow men.'15 This is Karl Marx, in the Communist Manifesto, speaking at mid-century of the dynamic destructiveness and self-disintegration inherent in the capitalist system and bourgeois society more generally. 'By "modernity" I mean the ephemeral, the contingent, the half of art whose other half is the eternal and the immutable.'16 This is Baudelaire, in 'The Painter of Modern Life', speaking of Modern Beauty, and suggesting that the painter of modern life is one who concentrates his energy on its fashions, its morals, its emotions, on 'the passing moment and all the suggestions of eternity that it contains'. 17 He who would be the 'peintre de la vie moderne' urban. Parisian and of course masculine – must dissolve himself in the urban crowd, setting 'up his house in the heart of the multitude, amid the ebb and flow of motion, in the midst of the fugitive and the infinite. '18 Marshall Berman, in a chapter on Baudelaire subtitled 'Modernism in the Streets', maintains that it is crucial to note Baudelaire's use of concepts of fluidity - 'floating existences' - and gaseousness (which 'envelops and soaks us like an atmosphere') as symbols for the distinctive quality of modern life and stresses the fact that fluidity and vaporousness would become primary qualities in the self-consciously modernist painting - as well as music and literature - that would emerge later in the century.19

The Impressionist painters of the 1870s hardly needed to learn about modernity and the modern city from Marx or even Baudelaire: and, certainly, the fluidity and vaporousness, the disintegrative structure and open brushwork they developed to accommodate to the urban body in pieces in their cityscapes rise from different roots and sources, including, of course, that primary source of modern visual culture, photography.²⁰ But their paintings of the urban, specifically Parisian, vista share with

Marx and Baudelaire a sense of that loss of solidity, a compensatory dynamism and flow, a sometimes centrifugal and often random organization and, above all, the notion that fragmentariness, in the broadest sense of that term — including both the cut-off view of the body and the cropped picture-surface — is a quality shared in the modern city by both the perceiver-constructor and the object of perception.

Degas' centrifugal vision of the Place de la Concorde, with its cut-off figure, divergent directions of movement and empty centre; Caillebotte's equally de-centred study of urban mobility and class, even species disconnectedness, in his *Pont de l'Europe*, with its well-dressed couple, isolated worker and prowling mongrel; or the latter artist's various views of the city from above, with cut-off figures and sense of human alienation; Monet's 'fluid' and 'vaporous' city views—to use Baudelaire's terms—in which the human crowds are reduced to mere 'cat-lickings' (to borrow the words of one unfriendly critic at the time) or blend into the misty cityscape in the background; or his multiple representation of that

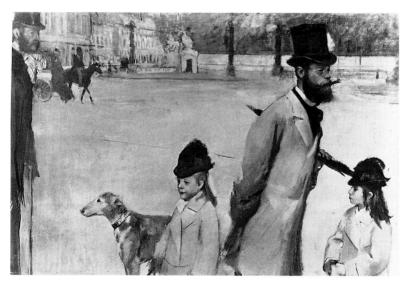

19 Edgar Degas, Ludovic Lepic and Daughters in the Place de la Concorde, mid-1870s.

19

20

22

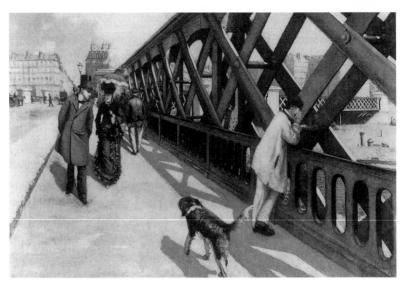

20 Gustave Caillebotte, Le Pont de l'Europe, 1876.

most modern of all entities, the railway station, as a mass of vaporous 21 iridescence, held in place by a fragile web of glass and iron, the waiting crowd of passengers merely suggested by partial and half-dissolved body-parts; and, finally, Pissarro's almost endless reiterations at the fin de siècle of the urban panorama from above – the Grands Boulevards picked out from hotel windows at various times of day, from various heights and angles - the Boulevard Montmartre as a glittering, light-dissolved 24 spectacle by night or as an equally fluid and vaporous emanation on a 25 misty winter morning - or the Place du Théâtre Français, with its 23 anonymous yet differentiated crowds swept up in an endless, seemingly haphazard pattern of movement from a point of view so high that, obliterating the horizon line, the traffic movement seems more than ever random and unmotivated – all these, no matter how different otherwise, share that sense of things falling apart, fragmented by revealed brushwork, and yet, at the same time, merging together to become that diaphanous, mobile and anonymous crowd that lies at the heart of modern sensibility: Marx's 'all that was solid' melting into air; Baudelaire's 'ebb and flow of motion, in the midst of the fugitive and the infinite'.

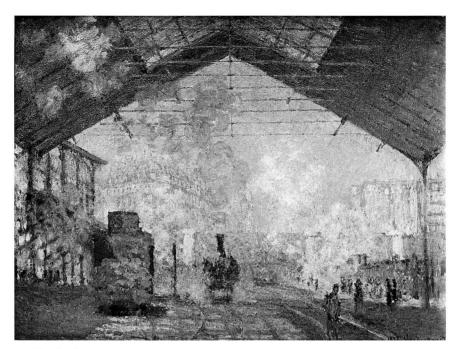

21 Claude Monet, Gare Saint-Lazare, 1877.

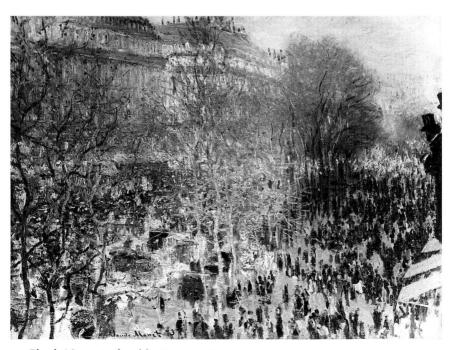

22 Claude Monet, Boulevard des Capucines, 1873.

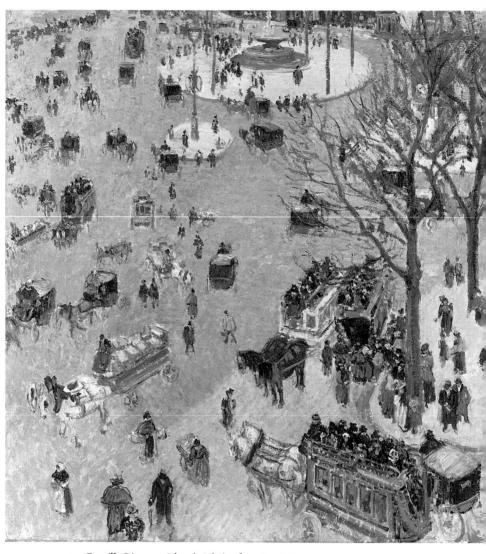

23 Camille Pissarro, Place du Théâtre français, 1898.

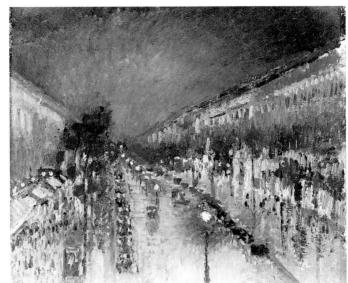

24 Camille Pissarro, Paris, the Boulevard Montmartre at Night, 1897.

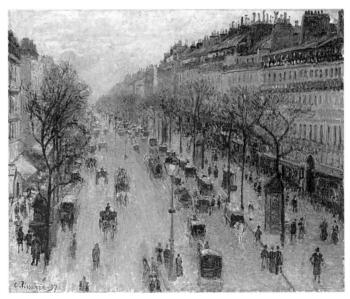

25 Camille Pissarro, The Boulevard Montmartre on a Winter Morning, 1897.

Impressionism was the first movement to be connected with the modern experience, not merely in terms of its subject matter but in its very manner of representation. Indeed, as David Frisby has pointed out in his book *Fragments of Modernity*, the German sociologist Georg Simmel, in attempting to analyze the experience of the great modern city in the early twentieth century, felt compelled to draw upon Impressionist stylistic strategies to articulate his sociological insights.²¹

There was one painter, associated with the Impressionist movement though never formally part of it, for whom the body in pieces assumed a

26 Edouard Manet, Music at the Tuileries, 1862.

27 Edouard Manet, The Old Musician, 1862.

more literal and yet a more complex role in the construction of modernity—and pictorial modernism—and that was Edouard Manet. Cropped compositions, compositions with fragmented figures, appear in Manet's work throughout his career and constitute a major characteristic of his style.

Quite early, in 1862, in *Music at the Tuileries*, a scene of modern urban life *par excellence*, he slices off part of his own figure at the left margin. In *The Old Musician* of the same year, he cuts off half of the figure of the old Jew with the right-hand margin.

26

27

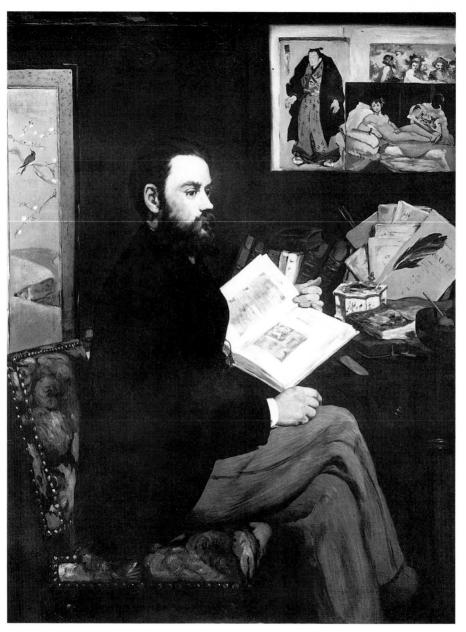

28 Edouard Manet, Portrait of Zola, 1868.

29 Edouard Manet, Portrait of Zola, 1868 (detail).

A more elusive—and provocative—kind of cut-off occurs in his 1868 Portrait of Zola. Here it is the image of his own work, the Olympia within the painting, that has been altered. Not only do the eyes of the reproduced Olympia swerve towards the sitter as though in gratitude for his defence of her reputation, as Theodore Reff has pointed out,²² but the margin of the photograph of the painting has been cropped on the right immediately against the body of the black cat, which had stood out with such memorable perversity in the original. The cropping here is a way of making the Olympia in the Zola portrait more modest, less sexually charged, in the presence of her knight-at-arms. The rather prim Zola had stoutly denied that Olympia was in any way obscene or sexually provocative. It is certainly possible that Manet, an inveterate blagueur, in a private visual joke between his friend and himself, substituted a chastened, as well as grateful, Olympia for the original.

28, 29

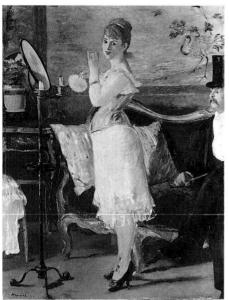

30

3 I

32, 33

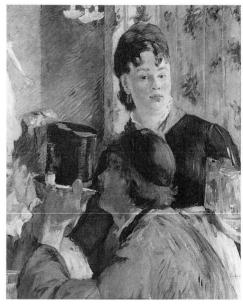

31 Edouard Manet, The Beer-Server, 1878-79.

More overt examples of partial figures with sexually suggestive overtones occur later in Manet's career as well, in the *Nana* of 1877, for example, where half, or perhaps a third, of a top-hatted man observes a seductively half-dressed young woman at her toilette; or in *The Beer-Server* of 1878–79, where a working-class man in a smock gazes towards a tantalising fragment of a female performer cut off by the left-hand margin of the painting.

Cut-off legs, suggesting the world beyond the barriers of the picture frame, signifying complex meanings within, turn up in Manet's last great work, the Bar at the Folies-Bergère of 1882. The little green boots of the trapezist at the upper left create a colouristic relation to the brilliant green crème-de-menthe bottle in the lower right foreground. Between these two points of reference, the barmaid exists as a kind of way station between the world of inert, densely painted commodities in the foreground and that of evanescent, openly brushed reflections of consumers

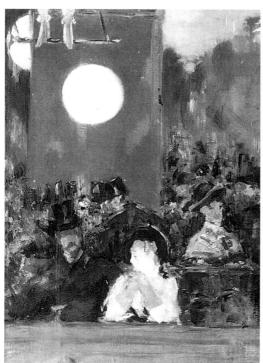

32 Edouard Manet, A Bar at the Folies-Bergère, 1882.

33 Edouard Manet, A Bar at the Folies-Bergère, 1882 (detail).

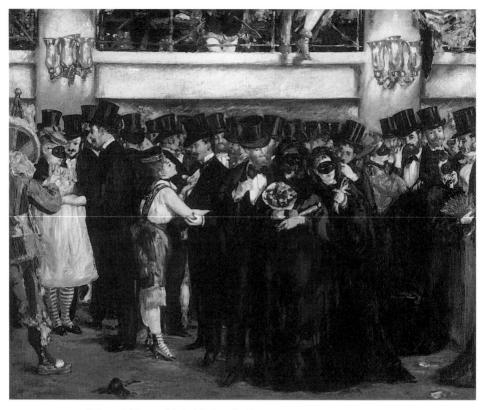

34 Edouard Manet, Masked Ball at the Opera, 1873.

of pleasure reflected in the mirror behind her, a world into which the green-shod feet, swinging for an incandescent moment above the luminous globe, like a slightly off-centre Fortuna above the orb of the world, seem to distil the transitoriness of modern pleasure itself.

There is one painting by Manet in which all the complex, and often contradictory, significations of the crop, the cut, and the fragmented figure in relation to the representation of modernity and the construction of modernism as a style are laid out in all their aspects: *Masked Ball at the Opera*, rejected for the Salon of 1874.²³ Here, we are confronted not only with a crowd of Parisian men-of-the-world, and dominoed and costumed women, but also with, at the left, half a Punchinello, and, at

34

the top, a female torso, a female leg and a sash hanging over the balcony. To paraphrase the painter's friend Mallarmé, who perfectly grasped the unusual coincidence of the casual and the deliberate in Manet's pictorial vision, the artist has here discovered a new 'manner of cutting down pictures' so that the frame has 'all the charm of a merely fanciful boundary, such as the view I would see if I framed my eyes with my hand at any given moment'. ²⁴ Manet's *Ball* and Mallarmé's comment deserve further analysis in relation to the theme of the body in pieces or the fragment as a metaphor of modernity. The analysis will be broken down into several oppositional alternatives.

First of all, I must oppose the significance of the cutting or cropping of the pictorial *space* itself to that of the fragmented *bodies* created by such cropping. Turning first to an examination of the cut-off view, the cropped picture surface in the *Ball*, I realize that it may itself suggest two opposing interpretations:

a. Total contingency: An equivalent of the meaningless flow of modern reality itself, a casual reality which has no narrative beginning, middle or end (Mallarmé's 'view I would see if I framed my eyes with my hand at any given moment'). This is a structure associated with aspects of nineteenth-century realism in art and literature, and with the new medium of photography as well.²⁵ Photography was often thought to be particularly 'artless' and, by the same token, particularly associated with reality, because of its tendency simply to record the raw data of visual experience, whatever happened to be caught by the lens at a particular time, whether or not a unified composition resulted, and whether or not human figures were oddly dissected by the photographic frame.

b. Total determination: The image is understood to be cropped, cut off, deliberately, as a function of the artist's will and aesthetic decision. The cut or the crop must be read as a strategy of that 'laying bare of the device' central to modernist creation. I am forced to pay attention to the formal organization of the picture surface, which becomes the realm of the pictorial *signifier*, not a simulacrum of reality, however modern.

c. A third alternative: I will read the cropped borders as a kind of designation of image-making as play, play with habitual boundaries of

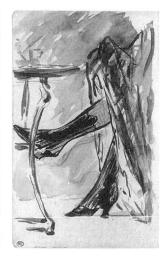

35 Edouard Manet, Masked Ball at the Opera, 1873 (detail).

36 Edouard Manet, Note to Mme Guillemet, 1880.

37 Edouard Manet, At the Café, c. 1880.

all sorts, an oscillation between contingency and determination frequently encountered in Manet's work and, I believe, central to his conception of the modern in art.

I will focus now on the cut-off elements, specifically on the legs and foot at the top of the painting and what and how they signify. The cut-off legs in the *Ball* can be read in at least three ways: first of all, as fetish. This fetishistic reading is demonstrated by the existence of a group of provocative drawings of legs and feet by Manet. In this reading, gender difference is the major factor in constituting the meaning of the cut-off feet and legs. That is to say, the fact that these are *women's* legs, not men's, is of great significance, since the male fragmented leg obviously signifies very differently from the female one. This point becomes particularly clear if we compare an image depending on the detached female leg with one depending on a male leg. Eugène Disdéri's photomontage of the spectacular legs and feet of contemporary ballerinas of the Opera ballet has distinctly erotic overtones, whereas Paul Renouard's cartoon

35

39

38

36, 37

comparing two sets of male legs – those of a radical and a conservative painting jury – does not. Rather, it is telling difference in details indicating *social* position that is at stake in the leg-work in the latter case.²⁶

Secondly, the fragmented legs can function metonymically, as synecdoches or part images of the body as a whole, references to the sexual attractiveness of the invisible owner or to the availability of still more

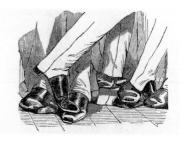

39 Cham, Opera Ball, in 'Le Bal Musard' from Les Physiologies parisiennes, c. 1840.

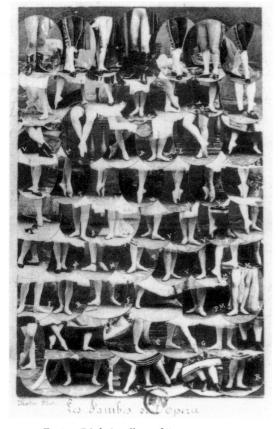

38 Eugène Disdéri, collage of six cartes de visite of legs and feet of ballerinas at the Opera, c. 1860.

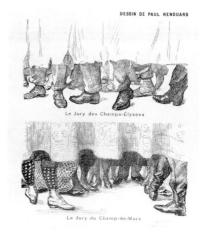

40 Paul Renouard, The Jury at the Champs-Elysées, The Jury at the Champs-de-Mars, 1877.

41 Gavarni, Les Débardeurs, plate 12 from Oeuvres choisis, 1840.

appetizing female bodies beyond the boundaries of the painting. Such metonymies were the stock/in/trade of 'low' or 'popular' artists, cartoon/ists especially, for whom playing with the signifiers was part of the humorous or suggestive vocabulary of their enterprise to a degree not open to serious high artists. This is apparent in the work of both Disdéri and Renouard discussed above. Metonymic references to legs even closer in spirit to those in Manet's Masked Ball at the Opera are apparent in caricatures like those from Gavarni's series Les Débardeurs, of 1840, where the motif of the slung thigh and the dangling leg function iconographically as signs of an unseemly casualness. The female legs clad in the provocative travesti costume of the débardeurs or longshoremen, a get-up popular among the young women who attended such occasions, are extremely close to Manet's invention in the Ball. Modernism, as Tom

4I

Crow has pointed out, has consistently renewed itself with the devices and strategies particular to popular or 'low' art since the mid-nineteenth century, and continues to do so right up to the present day.²⁷

Finally, these fragmented legs function as signboards advertising commodities, touting the erotic wares on offer at the Opera ball, rather like the clock hanging outside the clockmaker's shop or the shoe outside the cobbler's. To borrow the words of Meier-Graefe, who loved the picture and recognized its importance, the motif marks the theme of the painting as a Fleischbörse or fleshmarket.²⁸ On a more mundane level, it must be remarked that nineteenth-century advertising was itself replete with such part-images. Richly shod feet, not unlike those recorded by Manet in his drawings, appear in La Mode illustrée in January 1887; corset covers and bustles make their appearance in Le Moniteur de la mode of February 1884; isolated sleeves are objects of delectation in the pages of the same journal on 17 May 1884, and hats, with or without charming heads to show them off, were omnipresent in the fashion journals of the time. Men might derive fetishistic sexual satisfaction from the partimages on offer; women might see them as fashion hints and study them, even desire them, in quite different ways. One can well imagine some Emma Bovary of the provinces poring over the images of such fashionable feet or such effective corsets with a narcissistic avidity quite foreign to the usual definitions of fetishism.29

Like Manet, Degas resorts to the cut-off view, the crop and the fragmented figure in his representations of scenes of recreation in the great city. He, too, turns to the adventurous precedent set by low art — in this instance, the caricatures of Daumier — to establish the difference between, as it were, two levels of modern reality: the workaday world of the orchestra and the light-dissolved make-believe of the stage. Yet Degas puts this trope of opposition to more serious use. The world of reality, which we share with the members of the orchestra, is the site of a group portrait of serious male professionals, dully clad but individualized as physiognomic types and as musicians. The world of the women performers — their forms diaphanous, illusory, thinned out by stage light —

43,44

42

RIGHT: 42 Honoré Daumier, Orchestra during a Performance of a Tragedy, 1852.

BELOW: 43 Edgar Degas, Orchestra at the Opera, 1870.

OPPOSITE: 44 Edgar Degas, Cabaret, 1876.

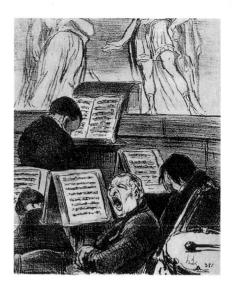

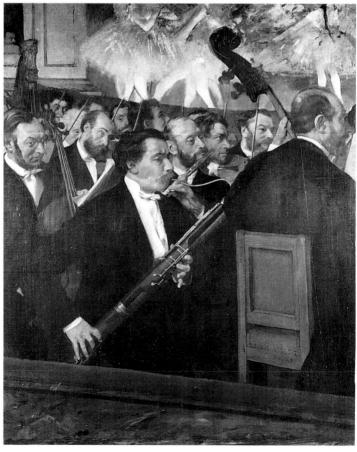

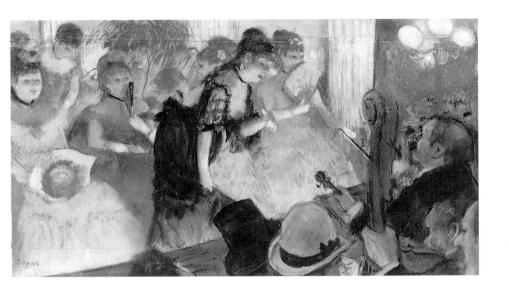

is undifferentiated, headless in fact, the performers guillotined by the top margin of the painting. The boundary between the two realms is sharply emphasized by the phallic profile of the head of the double-bass, a sexual metaphor which would later be used to good purpose by Toulouse-Lautrec in his posters advertising the Moulin Rouge and other dubious dance halls.

In the work of the 1880s, the cut-offs and the angles of vision become more daring, the pictorial language more insistently innovative. 'I want to show things as they have never been seen before,' Degas declares in one of his cahiers of the period.³⁰ Here, not just the performers but the audience itself is radically cropped — to the degree that, in the case of at least one version of the theme, the head and most of the body of the spectator are absent from the frame. The issue of 'relationship' in visual imagery is posed here in a new and paradoxical way. In Degas' more daring works, it must be stipulated as purely formal, constituted in this case by the way in which tutu and fan reiterate and re-echo each other as formal entities, as shapes, not as signs of human or narrative connection. They are connected only through the relation of specularity — and it is really our position of spectatorship, reiterating the original viewing position of the

45, 46

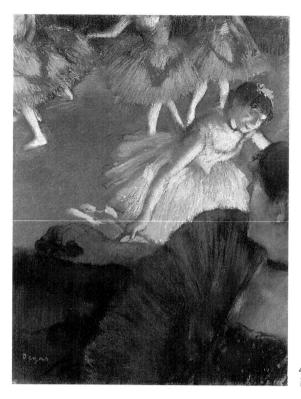

45 Edgar Degas, At the Ballet: Woman with the Fan, 1883–85.

46 Edgar Degas, At the Theatre, 1880.

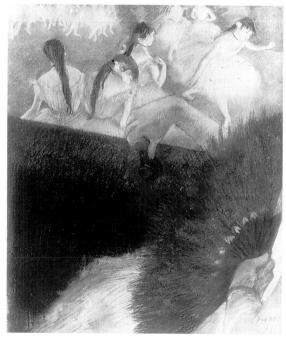

47 Edgar Degas, The Lowering of the Curtain, 1880.

artist, that holds the elements together. It is precisely the social and psychological distance between the dancer on stage and the elegant spectator in the box that is at once elided and at the same time evoked by the formal echoing of the semi-circular shapes that bind them in fortuitous connection. This refusal of conventional psychological connection, of traditional narrative, constitutes for us an essential part of Degas' modernity, his making it new. His modernism depends on this making strange of human relatedness. What else is this insistence on 'meaningless' but formally eloquent conjunction as the norm for the pictorial construction of contemporary social existence? At its most extreme, the Degas cut-off view may suggest that, like the ballet performance, the pictorial representation is nothing but convention, and just as the dance performance ends with the falling curtain, representation ends with an encroaching plane of colour, the erstwhile realism of the scene transformed into pure abstraction by the end of the act: a painted canvas divided into a lighter and a darker rectangle, a sort of Mark Rothko before the fact.

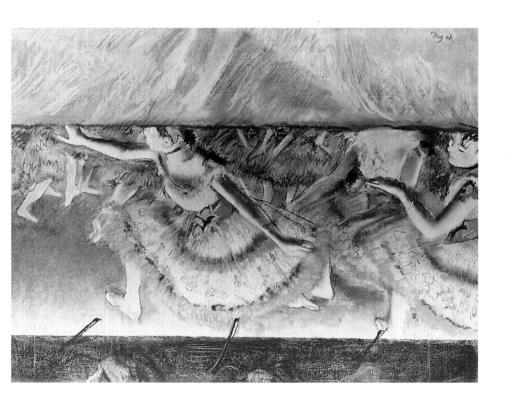

Not the open and mobile world of the modern city but the closed and sheltered one of the artist's studio serves as the site of the body in pieces in two rather unusual still lifes by Van Gogh and Cézanne respectively. The fragmented bodies in question are not those of the inhabitants of the

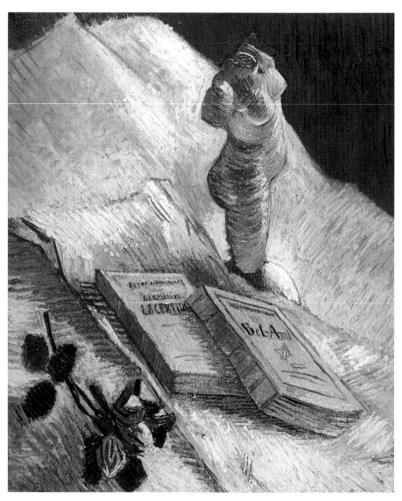

48 Vincent van Gogh, Still Life with a Rose, Two Books and a Plaster Cast of a Female Torso, 1887.

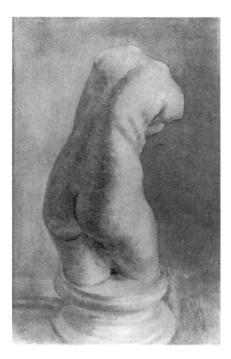

49 Vincent van Gogh, Study after Plaster Cast, 1886–87.

modern city, but of ancient, or at least older, statues, recalling in this respect the pathos of Fuseli's image. But this sense of pathos vanishes when it becomes apparent that it is not really fragments of antiquity which are at issue, but familiar studio props, headless or armless plaster casts rather than the genuine article. For many advanced artists of the nineteenth century such casts were reminders not so much of vanished glory as of a repressive academic education which they were all too ready to forget.

Indeed, in his youth, Van Gogh copied from the plaster cast, but it was faute de mieux. He complained that at the Antwerp Academy they rarely had an actual female nude to pose, and he seems to have left the place 'in disgrace for having painted a copy of the Venus de Milo with the big hips of a Flemish matron'. In Still Life with a Rose, Two Books and a Plaster Cast of a Female Torso, from the autumn of 1887, his attitude to the headless torso is less clear. The image is a complex one which centres on several sets of deeply felt tensions — between art and nature; words and

49

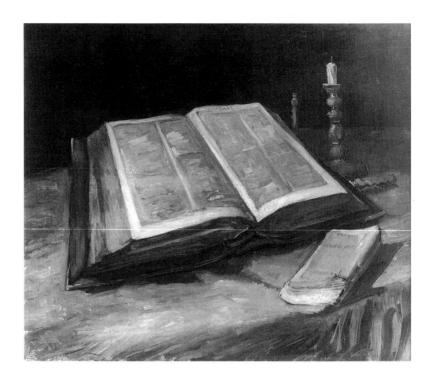

images; tradition and modernity — and the strong current of the erotic running beneath all these oppositions. Propped up within, or against a diagonally sliding backdrop of vibrant if muted yellow, the spiralling torso, seen from above, breast and belly thrust out, contrasts starkly in its verticality and its whiteness with the brightly coloured French novels sprawled at it base. The choice of novels is significant: both Edmond de Goncourt's Germinie Lacérteux and Guy de Maupassant's Bel-Ami are engaged with sexuality at its most abject and destructive. Perhaps Van Gogh wished to contrast the dubious authority of tradition embodied by the fragmented torso with the more vivid authenticity of the modern experience represented by the French novel, much as he had in his Still Life with Open Bible, Extinguished Candle and Zola's 'Joie de Vivre' two years earlier, where both the Bible and contemporary literary works had served in a similar capacity. But not quite. A woman's torso cannot help but signify differently from the family Bible: its ambiguous sexual

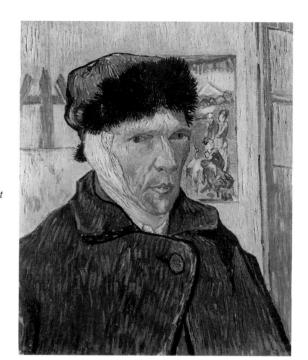

50 Vincent van Gogh, Still Life with Open Bible, Extinguished Candle and Zola's 'Joie de Vivre', 1885.

51 Vincent van Gogh, Self-portrait with Bandaged Ear, 1889.

domination of the scene is emphasized by the fact that it is both castrated and phallic at once; and by the suggestive implications of the rosebuds in the left foreground, which offer themselves and their overt sexual meaning to the spectator.

On the unconscious level, we may read the mutilation of the headless body as a potent metaphor of sacrifice — a fragmentation actualized in the living flesh of the artist two years later when he cut off part of his own ear and offered it to a prostitute. The Surrealist writer Georges Bataille, in an article entitled 'Sacrificial Mutilation and the Severed Ear of Vincent Van Gogh', maintained that art 'is born of a wound that does not heal'.³² Decapitation — any self-mutilation for that matter — is, for Bataille, the necessary precondition for any artistic undertaking. Unlike most art historians, who pass over Van Gogh's self-carving as a kind of embarrassment, irrelevant to the great achievement of his painting — although a contemporary artist might well see it as a performance piece

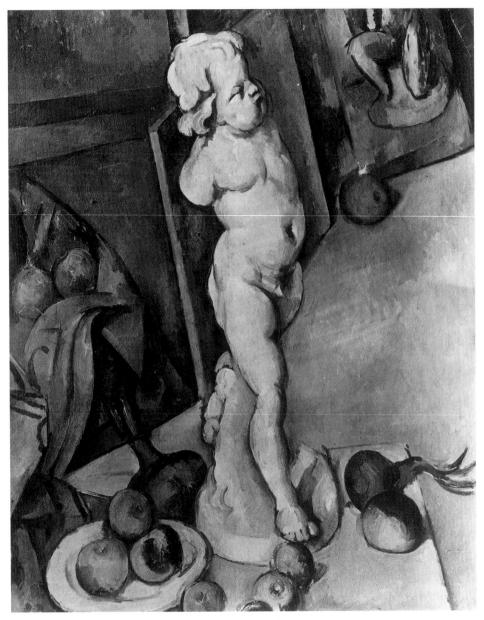

52 Paul Cézanne, Still Life with Plaster Cupid, c. 1895.

53 Paul Cézanne, drawing after a Cupid attributed to Puget, c. 1890s.

and therefore very much a part of his production — Bataille's interpretation of Van Gogh asserts that self-mutilation inspires rather than diminishes creation. As Carolyn Dean suggests in a 1992 study of Bataille, 'it is the gesture that [for Bataille] separates the painter who makes a contribution to art history from the painter who, like Van Gogh, paints the bloody myth of human existence.'33 The headless torso, then, functions as a powerful sacrificial object—like the head of the king—as well as an aesthetic and erotic one, in the unlikely context of the still-life genre.

Cézanne rarely includes a work of art within his still lifes, but in *Still Life with a Plaster Cupid* of around 1895, there are two, both at several removes from the original. Puget's *Cupid*, occupying the centre stage, is a plaster cast after the original, a cast which Cézanne drew many times

52

54, 55 Paul Cézanne, drawings after L'Ecorché, c. 1875-86.

from a variety of angles. The flayed figure in the background is represented as a painting within a painting after a cast of the original sculpture — four times removed from nature, as it were. The cupid, though lacking its arms, exists as a total entity within the image, love triumphant if a little spurious, centralized, vertical, dominating as it bulges and twists into the space of the picture; the other figure is fragmented — decapitated — not by time or chance but by the margin of the painting itself. It is one of Cézanne's strangest and most complicated pictures of the period: both crowded and yet empty at its centre, a work in which every element seems to be iterated at least twice: once as art and once as nature or reality. At the same time, and most importantly, even if this is a painting in which

cutting and cropping play a significant and even disturbing role, so do joining and suturing — of the most unexpected and daring kind: the way, for instance, the large onion on the left joins up with, even grows into, the fragmented still-life-within-the-still-life on the left, and the way that still life reciprocates by pouring its blue drapery down onto the 'real' table in the foreground, or the way the feathery sprout of the right-hand onion draws the luminous space of the empty floor up into its vital ambience. How truly this is a painting about art, about its objects and its processes — art conceived of as a joining up of unrelated fragments in a pictorial totality where the very arbitrariness of the cuts and joints emphasizes the artfulness of the project as a whole — a project which includes figures of both love and suffering.³⁴

We can now begin to see that it is by no means possible to assert that modernity may *only* be associated with, or suggested by, a metaphoric or actual fragmentation. On the contrary, paradoxically, or dialectically, modern artists have moved toward its opposite, with a will to totalization embodied in the notion of the *Gesamtkunstwerk*, the struggle to overcome the disintegrative effects — social, psychic, political — inscribed in modern, particularly modern urban, experience, by hypostatizing them within a higher unity. One might, from this point of view, maintain that modernity is indeed marked by the will toward totalization as much as it is metaphorized by the fragment.³⁵

As to the twentieth-century fate of the body in pieces, I can indicate it only in the most rudimentary way, despite the fact that the body fragment and the fragmentation of the body occupy a central if polyvalent place in the art of our period.³⁶ On the one hand, the bodily fragment – female – may function as a sign of the marvellous in Surrealist production, as it does in *La Femme cent têtes* of Max Ernst, itself a creation of fragments – a collage. On the other hand, reassembled in the form of horrific photographs of mutilated dolls, female body parts may serve as the site of transgressive questioning of both sexuality and the body as a unified entity in the work of the German artist Hans Bellmer, who was associated with the French Surrealist group.³⁷

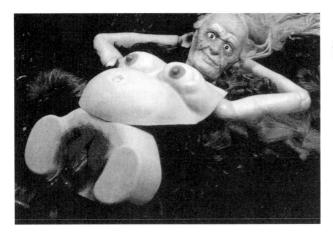

56 Cindy Sherman, *Untitled #250*, 1992.

In postmodernist production, the fragment assumes new, and differently transgressive, forms. In the sculpture of Louise Bourgeois, for instance, the part-object serves as the subverter of modernist rationality and formalist abstraction and as the site of a triumphant reintroduction of the abject in the form of infantile desire and gender-bending metamorphosis. The female sex organ is irrevocably de-fetishized in the entirely apotropaic prothesis photographs of Cindy Sherman and the de-sublimation — and, dare I say, domestication — of the male organ

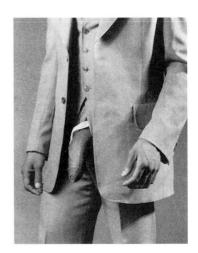

57 Robert Mapplethorpe, Man in Polyester Suit, 1980.

57

58

effected in the seductive, and fragmented, photographs of Robert Mapplethorpe. The postmodern body, from the vantage-point of these artists and many others, is conceived of uniquely as the 'body-in-pieces': the very notion of a unified, unambiguously gendered subject is rendered suspect by their work.

And, lest we forget the images we began with – Fuseli's Artist Overwhelmed by the Grandeur of Antique Ruins or the monarchal fragments disassembled by the French Revolutionaries – two near-contemporary postscripts may serve to remind us of the signifying power of the fragment: on the one hand, an anonymous photograph of the sculptor Jeanclos next to the colossal hand of Constantine on the Capitol, an

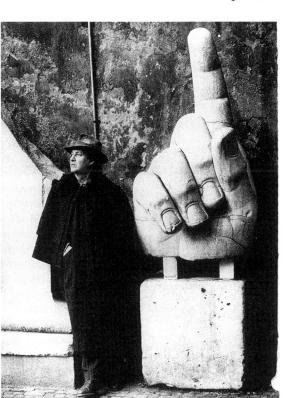

58 Anonymous, The Sculptor Jeanclos in front of the Hand of Constantine at the Capitol, 1983.

image which reminds us that the artist may be decidedly underwhelmed by the antique fragment in question;³⁸ and on the other, an installation view of Kryzsztof Bednarski's *Total Portrait of Marx*, of 1978, which reinstates the topos of the severed head of the leader as a potent metaphor of revolution, or would be revolution, and which has a particular significance today.³⁹

I do not wish to propose here some grandiose, all-encompassing 'theory of the fragment in relation to the concept of modernity'. That would go against the grain of my project. On the contrary, what I propose is that in examining, in a roughly historical order, a series of separate, though sometimes related, cases of the body in pieces, a paradigm is constructed of the subject under consideration. I firmly believe that the fragment in visual representation must be treated as a series of discrete, ungeneralizable situations. Were I to attempt to construct a general theory of the fragment, however, I would be sure to establish it on a model of difference rather than attempt to construct a unified field of discourse. For example, I would insist on differentiating the fragment in its ritualistic or psychosexual manifestations – as sacrifice or fetish – from its rhetorical role as metonymy or synecdoche in the work of realist artists. Above all, I would feel obliged to dissect or even deconstruct the very concept of modernity – itself a constantly changing discursive formation in which the trope of fragmentation plays a shifty and ever-shifting role - with as much care as I lavished on the fragment itself. But that would be another undertaking altogether.

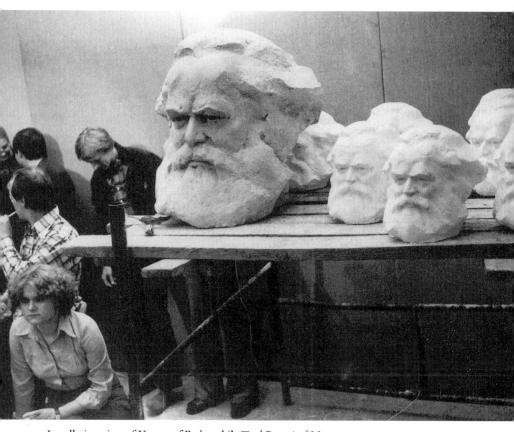

59 Installation view of Krzysztof Bednarski's Total Portrait of Marx, 1978.

NOTES

- Gert Schiff, in his magisterial catalogue of Fuseli's work, has suggested that this figure be considered a hidden self-portrait of the artist, connecting it with a related self-portrait drawing and maintaining that the 'body and pose are stylized, as Fuseli was wont to do, if he wished to transform an autobiographical sketch into something timeless'. (Gert Schiff, Johann Heinrich Füseli (1741–1825), Zurich Verlag Berichthaus; Munich, Prestel-Verlag, 1973, vol. I, p. 115.)
- 2 'La Révolution Française et l'Europe 1789–1799' was on view at the Grand Palais in Paris from 16 March to 26 June 1989.
- The Festival took place on 10 August 1893. The temporary statue of Liberty surmounted a collection of royal attributes, as one of the 'stations' of David's festival; these objects crowns, sceptres, orbs, even a portrait bust - were destroyed in a dramatic burst of flame as a great cloud of white doves was released overhead during the course of the ceremonies. See Mona Ozouf, La Fête Révolutionnaire, 1789-1799, Paris, Gallimard, 1976, p. 186, and Simon Schama, Citizens, New York, Alfred A. Knopf, and London, Viking, 1989, pp. 749-50 and fig. 184, p. 749.
- The colossus was planned by David to take the place of the statue of Henry IV

on the Pont-Neuf and described in a formal speech the artist gave before the Convention of 17 November 1793. See Lynn Hunt, *Politics, Culture, and Class in the French Revolution*, Berkeley and Los Angeles, University of California Press, 1984, pp. 98–100, for a complete description of the project.

Emmet Kennedy, A Cultural History of the French Revolution, New Haven and London, Yale University Press, 1989, p. 197. Contradictorily, according to François Furet, the guru of revisionist Revolutionary historians, it was the major project of the promulgators of Revolutionary ideology to reconstruct a supposedly already pulverized, almost non-existent, social body: 'Dès 89, la conscience révolutionnaire est cette illusion de vaincre un Etat qui déjà n'éxiste plus, au nom d'une coalition de volontés bonnes et de forces qui figurent l'avenir. Dès l'origine, elle est perpétuelle surenchère l'histoire réelle, comme si elle avait pour fonction de restructurer par l'imaginaire l'ensemble social en pièces [my italics].' François Furet, Penser la Révolution française, Paris, Gallimard, 1978, pp. 48-49. Yet ultimately these two notions are not as contradictory as they appear. It was precisely the visible vestiges of this dead, fragmented - and inequitable - social body that the revolutionaries set out to destroy, both

- literally in the form of iconoclasm and vandalism - and, more figuratively, in destructive texts and images. For a more complete discussion of the various heated debates and proposals concerning the destruction and/or conservation of the national patrimony, see Kennedy (note 5), pp. 197-234 and Edouard Pommier in Aux Armes & Aux Arts! Les Arts de la Révolution 1789-1799, ed. P. Bordes and R. Michel, Paris, Editions Adam Biro, 1988, pp. 175-97. The term 'vandalism' had been created by the Montagnards to condemn random acts of popular destruction, with an obvious reference to the Barbarians. 'Vandals and Goths' who had indiscriminately destroyed the heritage of Roman civilization. The Abbé Grégoire used the term as early as January 1794. (See Serge Bianchi, La Révolution culturelle de l'an II, Paris, Aubier, 1982, pp. 166-68.)
- 7 Daniel Arasse: La Guillotine et l'imaginaire de la Terreur, Paris, Flammarion, 1987.
- 8 'La guillotine "tranche les têtes avec la vitesse du regard", according to one contemporary observer. Cited in Arasse (note 7), p. 49.
- 9 I will not rehearse the elaborate scenario of castration, specularity and signification that Neil Hertz brilliantly sets forth in relation to the Revolutionary imagery of decapitation including this print in his article 'Medusa's Head: Male Hysteria under Political Pressure', Representations 4 (Fall 1983): 27–54.
- 'In effect', declares Jérémie Benoît in the catalogue of the French Revolution

- exhibition (cat. no. 544, vol. I, p. 420), 'the gesture of monstrance (ostension), like that of the oath, participates in a notion going far beyond that of the Revolution itself: it is that of a founding gesture, which implies the social contract.'
- 11 Arasse (note 7), p. 67.
- 12 Nina Athanassoglou/Kallmyer, 'Géricault's Severed Heads and Limbs: The Politics and Aesthetics of the Scaffold', The Art Bulletin 74 (December 1992): 614.
- Rosalind E. Krauss, *Cindy Sherman*, 1975—1993, with an essay by Norman Bryson, New York and London, Rizzoli, 1993, pp. 93—94.
- 14 Ibid., p. 97.
- 15 Karl Marx, the Communist Manifesto, cited in Marshall Berman, All That Is Solid Melts Into Air: The Experience of Modernity, New York, Simon and Schuster, 1982, and London, Verso, 1983, p. 21.
- 16 Charles Baudelaire, 'The Painter of Modern Life', in *The Painter of Modern* Life and Other Essays, tr. and ed. by Jonathan Mayne, London, Phaidon, 1964, p. 13.
- 17 Ibid., pp. 4-5.
- 18 Ibid., p. 9.
- 19 Berman (note 15), p. 144.
- For an important examination of the relation of visual modernity and photography, see Jonathan Crary, Techniques of the Observer: On Vision and Modernity in the Nineteenth Century, Cambridge, Massachusetts, and London, MIT Press, 1990.
- 21 David Frisby, Fragments of Modernity: Theories of Modernity in the Work of Simmel, Kracauer and Benjamin,

- Cambridge, Polity Press, 1985, 38–108, and especially 40–41 and 75.
- 22 Theodore Reff, 'Maner's "Portrait of Zola", Burlington Magazine, January 1975, p. 41.
- 23 For a complete examination of Manet's Masked Ball at the Opera, as well as a preliminary setting forth of some of the points made here, see Linda Nochlin, 'Manet's Masked Ball at the Opera', in The Politics of Vision: Essays on Nineteenth-Century Art and Society, New York, Harper & Row, 1989, and London, Thames and Hudson, 1991, pp. 75–94.
- See Jean C. Harris, 'A Little-Known Essay on Manet by Stéphane Mallarmé', *The Art Bulletin* 46 (December 1964): 561. Mallarmé's essay had originally appeared in the English *Art Monthly Review* in 1876.
- For the association of the lack of narrative closure in art and literature with realism, and the association of realism with photography, see Linda Nochlin, *Realism*, Harmondsworth, Middx, Penguin Books, 1971, passim.
- For an incisive reading of the fetishistic significance of the female leg in the mid-nineteenth century, more specifically the legs of the notorious Countess de Castiglione, see Abigail Solomon-Godeau, 'The Legs of the Countess', October 39 (Winter 1986): 65–108.
- 27 Thomas Crow, 'Modernism and Mass Culture in the Visual Arts', in Modernism and Modernity: The Vancouver Conference Papers, ed. Benjamin H. D. Buchloh et al., Halifax, Nova Scotia, Nova Scotia College of Art and Design, 1983, pp. 215–64.

- Julius Meier-Graefe, Edouard Manet, Munich, 1912, p. 216.
- But see Emily S. Apter, Feminizing 29 the Fetish: Psychoanalysis and Narrative Obsession in Turn-of-the-Century France, Ithaca, N.Y., Cornell University Press, 1991, for a different interpretation of fetishism itself in relation to the feminine subject. Marx's definition of commodity fetishism - the existence of social relations between objects and material relations between persons - is also relevant to the understanding of the body parts represented here.
- Cited by Theodore Reff in 'The Chronology of Degas's Notebooks', Burlington Magazine, December 1965, p. 614.
- 31 Van Gogh, cited in Anne Pingeot, Le Corps en morceaux (exh. cat.), Paris, Musée d'Orsay, 1990, p. 142.
- 32 Georges Bataille, 'Sacrificial Mutilation and the Severed Ear of Vincent Van Gogh', in *Visions of Excess: Selected Writings 1927–1939*, ed. Allan Stoekl, Minneapolis, University of Minnesota Press, 1993, pp. 61–72
- 33 See Carolyn J. Dean, The Self and Its Pleasures: Bataille, Lacan, and the History of the Decentered Subject, Ithaca, N.Y., and London, Cornell University Press, 1992, pp. 232–34, for information on Bataille and Van Gogh as well as citations.
- 34 For the best and most complex analysis of this painting, see Meyer Schapiro, Cézanne, New York, Harry N. Abrams, 1952, p. 98.
- This claim has been made for one of the founding instances of modernity,

the French Revolution itself, by no less an authority than François Furet, who asserts that the Revolution 'sought to restructure, by an act of imagination, wholeness to a society that lay in pieces'. (Penser la Révolution française, Paris, Gallimard, 1978, pp. 48-49.) The role of the fragment in the art of 36 the twentieth century would require another book-length study. The same might be said of the fragment in relation to the sculpture of both the nineteenth and the twentieth centuries. In the case of the latter subject, however, there already exist several important texts, among them Le Corps en morceaux (exh. cat.), ed. Anne Pingeot, Paris, Musée d'Orsav, 1990. and the catalogue of the pioneering exhibition organized by Albert E. Elsen, The Partial Figure in Modern Sculpture: From Rodin to 1969, Baltimore Museum of Art, 1969-70, as well as an article by Elsen, 'Notes

- on the Partial Figure', Artforum 8 (November 1969): 58-63.
- 37 See Rosalind E. Krauss, L'Amour Fou: Photography and Surrealism, Washington, D.C., Corcoran Gallery of Art; New York, Abbeville Press, 1985, for a more complete account of Bellmer and Surrealist photography generally.
- 38 The photograph is taken from the catalogue, Le Corps en morceaux (note 36) p. 86, fig. 137. A similar photograph of the artist Robert Rauschenberg as a very young man standing next to the giant hand appeared in the New York Times on 10 April 1994, as an advertisement for an exhibition at the Chicago Art Institute. It seems to be a popular trope!
- 39 This photograph served as an illustration to Ewa Lajer-Burcharth's article 'Warsaw Diary', *Art in America*, February 1994, p. 87.

LIST OF ILLUSTRATIONS

- I. HENRY FUSELI, The Artist Overwhelmed by the Grandeur of Antique Ruins, 1778–79. Chalk and sepia wash. Kunsthaus, Zurich.
- 2. Fragment of a foot of an equestrian statue of Louis XIV, c. 1699. Bronze. Musée du Louvre, Paris. © Photo R.M.N.
- 3. JACQUES BERTAUX, Destruction of the Equestrian Statue of Louis XIV, 1792. Pen and ink wash. Musée du Louvre, Paris. © Photo R.M.N.
- 4. VILLENEUVE, Matière à réflection pour les jongleurs couronnées (Food for Thought for Crowned Charlatans), 1793. Engraving. Musée Carnavalet, Paris. Photo Photothèque des Musées de la Ville de Paris.
- 5. PIERRE-ETIENNE LESUEUR, Execution of Louis XVI, 1793. Pen and ink. Bibliothèque Nationale de France, Paris.
- 6. CARL AUGUST EHRENSVÄRD, Democrats Mingling with the Aristocracy, mid-1790s. Pen and brown ink. Private Collection, Sweden.
- ANONYMOUS, Devotion to One's Country,
 1794. Oil on canvas. Musée Carnavalet,
 Paris. Photo Giraudon.
- JAMES GILLRAY, Un Petit Souper à la Parisienne, or, A Family of Sans-Culotts Refreshing after the Fatigues of the Day, 1792. Engraving, British Museum, London.
- THÉODORE GÉRICAULT, The Wounded Cuirassier, 1814. Oil on canvas. Musée du Louvre, Paris.

- 10. THÉODORE GÉRICAULT, Execution in Italy, 1816. Pencil, pen and brown ink. Nationalmuseum, Stockholm.
- 11. THÉODORE GÉRICAULT, The Swiss Guard at the Louvre, 1819. Lithograph. Bibliothèque Nationale de France, Paris.
- 12. THÉODORE GÉRICAULT, Wounded Soldiers in a Cart, c. 1818. Oil on canvas. Fitzwilliam Museum, Cambridge.
- 13. THÉODORE GÉRICAULT, Severed Limbs, 1818. Oil on canvas. Musée Fabre, Montpellier.
- 14. THÉODORE GÉRICAULT, Severed Limbs, c. 1819. Oil on canvas. Private Collection.
- 15. THÉODORE GÉRICAULT, Head of a Dead Man, sometimes called The Executed Criminal, c.1818–19. Oil on canvas. Private Collection, Paris.
- 16. THÉODORE GÉRICAULT, Severed Heads, 1818. Oil on canvas. National-museum. Stockholm.
- 17. DOMINIQUE VIVANT DENON, Severed Head of Robespierre, 1794. Engraving. The Metropolitan Museum of Art, New York, Rogers Fund, 1962 (62.119.8b).
- 18. CHARLES-EMILE CALLANDE DE CHAMPMARTIN, After Death, Head of a Dead Man, 1818—19. Oil on canvas. The Art Institute of Chicago, A.A.Munger Collection, 1937. 502. Photo © 1994, The Art Institute of Chicago. All Rights Reserved.

- 19. EDGAR DEGAS, Ludovic Lepic and Daughters in the Place de la Concorde, mid-1870s. Oil on canvas, destroyed during World War II. Photo courtesy Calmann King Ltd.
- 20. GUSTAVE CAILLEBOTTE, Le Pont de l'Europe, 1876. Oil on canvas. Musée du Petit Palais, Geneva.
- 21. CLAUDE MONET, Gare Saint-Lazare, 1877. Oil on canvas. Musée d'Orsay, Paris.
- 22. CLAUDE MONET, Boulevard des Capucines, 1873. Oil on canvas. Pushkin Museum, Moscow.
- 23. CAMILLE PISSARRO, *Place du Théâtre français*, 1898. Oil on canvas. Los Angeles County Museum of Art, Mr. and Mrs. George Gard de Sylva collection.
- 24. CAMILLE PISSARRO, Paris, the Boulevard Montmartre at Night, 1897. Oil on canvas. Reproduced by courtesy of the Trustees, The National Gallery, London.
- 25. CAMILLE PISSARRO, The Boulevard Montmartre on a Winter Morning, 1897. Oil on canvas. The Metropolitan Museum of Art, New York, Gift of Katrin S. Vietor (Mrs E.G.), in loving memory of Ernest G. Vietor, 1960.
- 26. EDOUARD MANET, Music at the Tuileries, 1862. Oil on canvas. Reproduced by courtesy of the Trustees, The National Gallery, London.
- 27. EDOUARD MANET, *The Old Musician*, 1862. Oil on canvas. © 1994 National Gallery of Art, Washington D.C., Chester Dale Collection, 1962.
- 28, 29. EDOUARD MANET, Portrait of Zola, 1868. Oil on canvas. Musée d'Orsay, Paris.

- 30. EDOUARD MANET, Nana, 1877. Oil on canvas. Kunsthalle, Hamburg.
- 31. EDOUARD MANET, The Beer-Server, 1878–79. Oil on canvas. Musée d'Orsay, Paris.
- 32, 33. EDOUARD MANET, A Bar at the Folies-Bergère, 1882. Oil on canvas. Courtauld Institute Galleries, London.
- 34, 35. EDOUARD MANET, Masked Ball at the Opera, 1873. Oil on canvas. © 1994 National Gallery of Art, Washington D.C., Gift of Mrs Horace Havemeyer in memory of her mother in law, Louisine W. Havemeyer.
- 36. EDOUARD MANET, *Note to Mme Guillemet*, 1880. Note, with watercolour. Musée du Louvre, Paris, Cabinet des Dessins. © Photo R.M.N.
- 37. EDOUARD MANET, At the Café, c. 1880. Watercolour. Musée du Louvre, Paris, Cabinet des Dessins. © Photo R.M.N.
- 38. EUGÈNE DISDÉRI, Six cartes de visite of legs and feet of ballerinas at the Opera, c. 1860. Photographic collage. Bibliothèque Nationale de France, Paris.
- 39. CHAM, Opera Ball, in 'Le Bal Musard' from Les Physiologies Parisiennes, c. 1840. Engraving. British Museum, London.
- 40. PAUL RENOUARD, The Jury at the Champs-Elysées. The Jury at the Champs-de-Mars, 1877. Engraving. Bibliothèque Nationale, Paris.
- 41. GAVARNI, 'Les Débardeurs', plate 12 from *Oeuvres choisis*, 1840. Engraving. British Museum, London.
- 42. HONORÉ DAUMIER, Orchestra during a Performance of a Tragedy, 1852. Lithograph.

- 43. EDGAR DEGAS, Orchestra at the Opera, 1870. Oil on canvas. Musée d'Orsay, Paris. © Photo R.M.N.
- 44. EDGAR DEGAS, Cabaret, 1876. Pastel over monotype. Collection of the Corcoran Gallery of Art, Washington D.C., William A. Clark Collection.
- 45. EDGAR DEGAS, At the Ballet: Woman with the Fan, 1883-85. Pastel on paper. Philadelphia Museum of Art, The John G. Johnson Collection.
- 46. EDGAR DEGAS, At the Theatre, 1880. Pastel on paper. Private Collection. Photo Archives Durand-Ruel.
- 47. EDGAR DEGAS, The Lowering of the Curtain, 1880. Pastel on paper. Private Collection.
- 48. VINCENT VAN GOGH, Still Life with a Rose, Two Books and a Plaster Cast of a Female Torso, 1887. Oil on canvas. Vincent van Gogh Foundation/National Museum Vincent van Gogh, Amsterdam.
- 49. VINCENT VAN GOGH, Study after Plaster Cast, 1886–87. Black chalk. Vincent van Gogh Foundation/National Museum Vincent van Gogh, Amsterdam.
- 50. VINCENT VAN GOGH, Still Life with Open Bible, Extinguished Candle and Zola's 'Joie de Vivre', 1885. Oil on canvas. Vincent

- van Gogh Foundation/National Museum Vincent van Gogh, Amsterdam.
- 51. VINCENT VAN GOGH, Self-portrait with Bandaged Ear, 1889. Oil on canvas. Courtauld Institute Galleries, London.
- 52. PAUL CÉZANNE, Still Life with Plaster Cupid, c. 1895. Oil on canvas. Courtauld Institute Galleries, London.
- 53. PAUL CÉZANNE, drawing after a Cupid attributed to Puget, c. 1890s. Pencil. British Museum, London.
- 54, 55. PAUL CÉZANNE, two drawings after L'Ecorché, c. 1875–86. Pencil. The Art Institute of Chicago, Arthur Henn Fund, 1951.1. page 19 recto, page 20 recto.
- 56. CINDY SHERMAN, Untitled #250, 1992. Photograph. Photo Metro Pictures, New York.
- 57. ROBERT MAPPLETHORPE, Man in Polyester Suit, 1980. Photograph. Copyright © 1980, The Estate of Robert Mapplethorpe.
- 58. Anonymous, The Sculptor Jeanclos in front of the Hand of Constantine at the Capitol, 1983. Photograph. Private Collection.
- 59. Installation view of Krzysztof Bednarski's *Total Portrait of Marx*, 1978. Plaster busts, photographs, mixed media, at the Repassage Gallery, Warsaw.